3 1243 00456 5247

Lake Forest Library
360 E. Deerpath
2/10
Lake Forest, IL 60045
847-234-0636
www.lakeforestlibrary.org

Skira**M**ini**ART**books

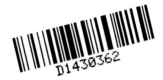
D1430362

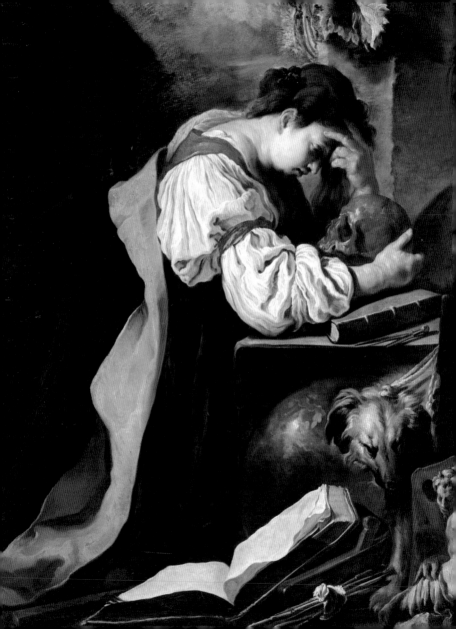

Flaminio Gualdoni

STILL LIFE

SKIRA

Front cover
Juan Sánchez Cotán
Still Life with Cabbage, Melon and Cucumber, before 1603
Oil on canvas,
68.9 x 84.5 cm
Museum of Art, San Diego

Skira editore
SkiraMiniARTbooks

Editor
Eileen Romano

Design
Marcello Francone

Editorial Coordination
Giovanna Rocchi

Editing
Maria Conconi

Layout
Anna Cattaneo

Iconographical Research
Alice Spadacini

Translation
Christopher "Shanti" Evans
for Language Consulting
Congressi, Milan

First published in Italy in 2009
by Skira Editore S.p.A.
Palazzo Casati Stampa
via Torino 61
20123 Milano
Italy

www.skira.net

No part of this book may be reproduced or utilized in any form or by any means, electronic or mechanical, including photocopying, recording, or any information storage and retrieval system, without permission in writing from the publisher.

© 2009 by Skira editore
All rights reserved under international copyright conventions.

Printed and bound in Italy.
First edition

ISBN 978-88-6130-0046-3

Distributed in the US and Canada through Rizzoli International Publications by Random House, 300 Park Avenue South, New York, NY 10010.
Distributed elsewhere in the world by Thames and Hudson Ltd., 181a High Holborn, London WC1V 7QX, United Kingdom.

Facing title page
Domenico Fetti
Meditation (detail), *circa* 1618
Oil on canvas, 179 x 140 cm
Gallerie dell'Accademia, Venice

On page 90
Robert Mapplethorpe
Pheasant, 1984
Silver gelatine print, 50.5 x 40 cm
Robert Mapplethorpe Foundation, New York

© The Bridgeman Art Library / Archivi Alinari, Firenze
© Foto Archivio Scala, Firenze, 2009
© Luciano Romano
© Photo CNAC/MNAM, Distr. RMN / Jacqueline Hyde, Philippe Migeat, Bertrand Prévost – Réunion des Musées nationaux / Distr. Alinari
© RMN / Martine Beck-Coppola, Gérard Blot, René-Gabriel Ojéda – Réunion des Musées nationaux / Distr. Alinari
© RMN (Musée d'Orsay) / Hervé Lewandowski – Réunion des Musées nationaux / Distr. Alinari
© Salvador Dalí, Gala-Salvador Dalí Foundation, by SIAE 2009
© FLC, by SIAE 2009
© The Robert Mapplethorpe Foundation
© Andy Warhol Foundation for the Visual Arts, by SIAE 2009
© Jean-Pierre Alaux, Georges Braque, Giorgio de Chirico, Filippo De Pisis, Renato Guttuso, Fernand Léger, René Magritte, Giorgio Morandi, Jean-Luc Moulène, Georges Rohner, Pierre Roy, Tom Wesselmann, by SIAE 2009

Contents

Still life

"Here is the plush velvet of the peach, the amber transparency of the white grape, the sugary frost of the plum, the moist crimson of the strawberries, the compact red grapes with their bluish film of mist, the wrinkles and warts of the orange, the raised lace of the melons, the blush of the old apples, the knots in the crust of the bread, the smooth skin of the chestnuts and even the wood of the hazelnut. It is all here before us, in the light and the air, almost within our reach." This is how Edmond and Jules de Goncourt described a still life by Jean-Baptiste-Siméon Chardin, offering us a perfect summary of one of most popular genres in the history of art. In it we find the delight of the eyes, the admiration for the artist's skill in almost magically reproducing the visible world, the sense of a concrete, living experience that he conveys through the painted image.

The still life is the triumph of the exact, indulgent representation of things of no importance, that do not set out to reveal anything but themselves, to the delight of the hand that has painted them and of the eye that relishes the sight of them. This how the Goncourt brothers saw it in the 19th century, recapitulating a tradition that had its beginnings in the 16th century and that in the following century became so prominent as to turn into an artistic genre in its own right, with a recognized status of its own. Of course, the still life was not born then. Images of food and objects placed on a support date all the way back to Greek and Roman antiquity, and from the Middle Ages right through the Renaissance were produced with a certain regularity. What changed between the 16th and 17th century is that, at a certain point, they acquired a sort of dignity of their own. No longer were they the complement of a more noble representation or a set of symbolic allusions, but were intended instead to offer the viewer their own naked quality, in a sort of

paean to the beauty of the real that turned into beauty of the painted. The stages in the process that led up to that moment were numerous and important. Pliny the Elder relates in the *Naturalis Historia* that Zeuxis painted some grapes in a contest with Parrhasius to decide which of the two was the greater artist. The Greek and then Roman custom of placing on the table in the guest's room "hospitable gifts", known as *xenia*, consisting of food and drink, was transformed into that of painting pictures reproducing those gifts: fruit, vegetables, loaves of bread, eggs, pots of milk, jugs of water and wine. The Hellenistic and Roman mosaics expanded on this tradition, going so far as to decorate entire floors with rows of animals, especially fish, in a taste for the picturesque and for virtuosity of representation that would be inherited by the Renaissance.

Jacopo de' Barbari
Still Life, 1504
Oil on wood, 52 x 42.5 cm
Alte Pinakothek, Munich

The emergence in Europe of an art of exclusively Christian inspiration and patronage modified the *raison d'être* of the image. The appreciation of the artist's skill and the taste for pleasing subjects gave way to the expression of supreme values, to the project of an art whose only purpose lay in the relationship with the infinite, with the divine, through the manifestation of its absolute values. In this milieu the still life disappeared as an artistic genre in its own right, or was transformed into an element subsidiary to the construction of meaning. The laying of the table for a *Last Supper*, the objects used in worship arranged for the rite and the attributes characteristic of a saint (a typical example is the iconography of Saint Jerome in his study, where he is identified by a book, a pair of spectacles and an hourglass on the desk) could become a "picture within the picture", i.e. turn the ancient model of the still life into a fundamental accessory of the architecture of the sacred image.

8

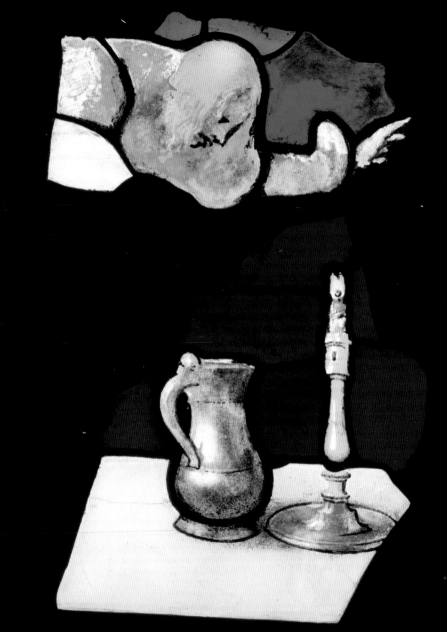

It was in the culture of the Renaissance, however, that the twofold condition was created which would give the decisive impetus to the birth of the genre of the still life as we know it.

On the one hand, the rediscovery and revival of antiquity by Humanistic culture brought back into fashion the model of the Hellenistic-Roman still life. Raphael, who drew and reinvented the grotesques of Roman painting, is the most eloquent example of this: Vasari reminds us that Giovanni da Udine, Raphael's pupil and collaborator, "succeeded in copying convincingly (...) every natural object, animals, fabrics, implements, vessels, landscapes, buildings and vegetation". But no less important were the images created by the technique of intarsia, a form of wood inlaying that was used for purely decorative purposes from the late 15th century onward, culminating in masterpieces like the studies created for Federico da Montefeltro at Urbino and Gubbio between 1472 and 1482: musical instruments, books, clocks, sheets of music and geometric objects set on mock shelves and benches became the exclusive protagonists of the image. Even deeply Christian Italy began to show a penchant for antiquity and paganism, treasuring and collecting relics of the past and progressively secularizing its taste. The spread of the still life and the passion for mythological iconography indicate that at this moment room was being created for a new appreciation of the image not dependent on its devotional implications, but founded entirely on its autonomous aesthetic qualities.

In the second place, within the space of a few decades the Protestant Reformation, in which a strong current of iconoclasm was at work,

Engrand le Prince (?-1531)
Still Life with Angel (detail), 56 x 46 cm
Musée national de la Renaissance, Écouen

started to belittle, and even deny, the devotional significance of sacred images. Calvin recommended that "the only things (...) which ought to be painted or sculptured, are things which can be presented to the eye; the majesty of God, which is far beyond the reach of any eye, must not be dishonoured by unbecoming representations", and the Protestant middle class of Northern Europe, released from the obligation of a sacred art, began to appreciate the skill of its painters as a value in itself. Flemish artists, in particular, reproduced ordinary objects in astonishing detail, trivial things that were redeemed by their representation and given significance as marks of an everyday affluence that no longer required external guarantees, whether religious or political, to lay claim to its own dignity.

Giuseppe Arcimboldo
Vertumnus (detail),
circa 1590
Oil on wood, 68 x 56 cm
Skokloster Castle,
Sigtuna, Uppsala

Plinio spoke of "rhopography" and "rhyparography", i.e. of the kind of painting that took minor and common things as its subjects, not noble in themselves. Now, in the optimistic and prosperous north, where people delighted in surrounding themselves with pleasing images even if they no longer expressed the eternal but, as the philosopher Georg Wilhelm Friedrich Hegel was to put it, "particularities in their specific individuality and fortuity of change and transformation", the talk was of single and highly characterized themes: the composition of fruit, the vase of flowers, the breakfast piece, the laid table, the trophy and the still life with smoking implements, with the specific variants of the *vanitas* (the *doodshoofd* or "death's head" in Flanders and the Netherlands) and the *trompe-l'oeil* (*betriegertje*): the former characterized by a skull or symbols alluding to the brevity and vanity of life, such as candles, hourglasses, soap bubbles, mirrors, jewels or rotting fruit (the wormy apple and withered leaves in Caravag-

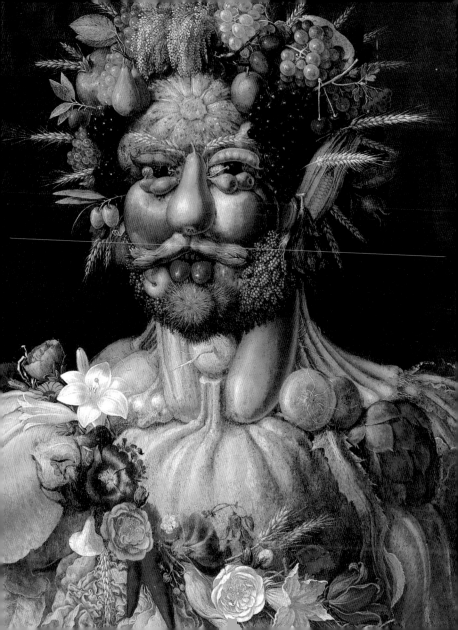

gio's famous *Basket of Fruit* show that it too is a *vanitas*); the second specifically designed to create optical illusions.

The Flemish term *stilleven*, indicating a representation of immobile nature, from which the German *Stilleben* and the English *still life* derive, and embracing all those specialist images, would only be coined in 1650, in connection with the works of Willem van Aelst, a Dutch painter from Delft who was also active in France and at the Florentine court of Ferdinando II de' Medici. For the French term *nature morte*, "dead nature", from which the Italian *natura morta* derives, it would be necessary to wait for another century and Baillet de Saint-Julien's *Lettre sur la peinture à un amateur* of 1750. Up until that moment artists preferred to describe themselves, following a logic that also reflected precise marketing needs, as "painters of fruit", "painters of laid tables", "painters of breakfast pieces" and so on, and to set up out-and-out specialized schools: the finest laid tables could be bought at Haarlem, while for *vanitas* one had to go to Leiden.

Nor was this all. Each artist became known within the production of his genre for certain typical stratagems – a particular way of arranging certain objects, of handling reflections of light – and this not only determined his success but also led to a proliferation of often identical works that were churned out by his workshop at the explicit request of buyers, and to the spread of imitations exploiting the fashionable taste. In some ways, it can be said that this was the true origin of the modern art market, in which the ease of recognition of the artist and the uniformity of his products acquired a commercial value that took the place of the cult of the uniqueness of the individual masterpiece.

If developments in the Low Countries were decisive for the popularity of the still life in Europe, it has to be said that the decisive steps

in its incubation during the 16th century were taken in Italian art. The attention to the natural and to accuracy of description, something which the Italian school also learned from those of Flanders and Germany (from Dürer to the naturalistic illustrations of Konrad Gessner), led to some extraordinary work in the specifically scientific field: from Giorgio Liberale da Udine's plates for an edition of Dioscorides in 1568 to the eighteen volumes of faithful illustrations of the "theatre of nature" commissioned in Bologna by the scientist Ulisse Aldrovandi and the meticulous depictions of flora by Jacopo Ligozzi for the Florentine court.

But another kind of fidelity to nature, which emerged from the scientific one thanks to the eclectic example of Leonardo and evolved into a pictorial genre in its own right, was also developed at the height of the 16th century by Paduan artists like Vincenzo Campi and Bartolomeo Passarotti, authors of folk scenes in which the still life was no longer just a visual intermezzo. At the same time the bizarre and manneristically grotesque heads made up of fruit, books and vegetables produced by the sardonic genius of the Milanese painter Arcimboldo became popular all over Europe.

It was the milieu of Lombard painting, moreover, that shaped the absolute genius of still life, Caravaggio, whose *Basket of Fruit* is the paradigm of the genre. And it was Caravaggio who bestowed on the still life the dignity of a theme worthy of being considered on a par with those traditionally regarded as more noble. Vincenzo Giustiniani, one of the artist's most prestigious clients, described in a letter the spread "not just in Rome, Venice and other parts of Italy, but also in Flanders and France" of the vogue for an easel painting that turned on "the ability to portray flowers and other minute things", of which "Caravaggio

said that it was as difficult for him to make a good painting of flowers as one of figures", and that it was therefore work of equal artistic challenge, skill and respectability. In the circle of Roman artists influenced by Caravaggio there were several who made a name for themselves in the specific field of the still life, defining the model of a lucidly realistic painting attentive to dramatically natural values of light, from Tommaso Salini to Bartolomeo Cavarozzi, while Flemish masters like Jan Brueghel the Elder diffused Northern European models in Italy, in the same years as Caravaggio's early successes.

There were many Flemish painters who saw their art circulated widely in Europe: Frans Snyders and Jan Fyt, Pieter Claeszoon and Willem Claeszoon Heda, Willem Kalf and Willem van Aelst, Osias Beert and Abraham van Beyeren, Maerten Boelema de Somme and the Bosschaerts, the Brueghels and Floris Claeszoon van Dijck, Juan van der Hamen, Jan de Heem and Floris van Schooten. Among the foreign artists to set up studios in Rome there would be Flemish and German specialists in the genre, such as Abraham Brueghel, Karel van Vogelaer, Franz Werner Tamm and Christian Berentz. The fact that their works were easel paintings, and therefore transportable, and that the size of the pictures usually allowed them to be hung in middle-class houses and not just in spacious stately homes, meant that possessing them became a sort of must in a climate of love for art that blended cultural appreciation and display of luxury, fashionable taste and ostentation on the cheap, just as a few generations earlier it had been essential for an aristocrat to possess the works of those who, as Vasari put it, knew the "secret" of "painting in oil" and painstakingly reproducing details, from Jan van Eyck

Jaroslav Rossler
Thymolin, 1935-39
Photography, 6.6 x 5.8 cm
Musée national d'Art
moderne – Centre
Georges Pompidou, Paris

to Rogier van der Weyden, from Justus of Ghent to Hans Memling and to Hugo van der Goes, from whom Leonardo got the idea for his meticulous depiction of nature.

In Northern Italy the well-established local tradition produced some outstanding artists, such as the Lombards Fede Galizia, Panfilo Nuvolone and especially Evaristo Baschenis, true master of the theme of the still life with musical instruments, and the Emilians Paolo Antonio Barbieri, Guercino's brother, Felice Boselli, who carried on with the folk theme, the sumptuous Pier Francesco Cittadini and the mature and lofty Cristoforo Munari and Giuseppe Maria Crespi. But Genoa was the city that had the closest contacts with Flemish art, even playing host to the prestigious studio of Jan Roos, a pupil of Snyders, and becoming famous for the opulent taste of Bernardo Strozzi and Giovanni Benedetto Castiglione called Grechetto, in which the still life was combined with the figure, and above all for the distinctive, and no less successful, genre of the portrayal of live animals.

Medicean Florence, in addition to being one of the places where the vogue for collecting still lifes was strongest, saw the naturalistic taste of Ligozzi reflected in the paintings of Jacopo da Empoli and Giovanna Garzoni, while Filippo Napoletano and Bartolomeo Bimbi reinterpreted the Flemish taste, turning it into a sort of baroque theatre of nature.

Spain developed a tradition of its own, influenced by the Flemish one but with more specific folk traits and less interested in the dramatic baroque approach to the presentation of natural and artificial objects. In fact the preferred Spanish term for the genre is *bodegón*, a word indicating the pantry or the tavern. Juan de Arellano, Francisco Barrera,

René Magritte
Personal Values
(detail), 1952
Oil on canvas, 80 x 100 cm
Museum of Modern Art,
San Francisco

Pedro de Camprobín, Juan de Espinosa and above all Juan Sánchez Cotán and Francisco de Zurbarán were the masters of the genre, whose influence, partly due to historical and political ties, extended to Southern Italy. Thus in Naples the lesson of crude realism imparted by Caravaggio, whose presence in the city had an influence on many artists, was blended with that of the Spanish school, resulting in the magnificent but accurate paintings, absolutely typical in the precision of their description and their handling of light, of figures like Luca Forte, Paolo Porpora, Giuseppe Recco and Giovan Battista and Giuseppe Ruoppolo.

Flemish art circulated in France too, giving rise to a not particularly prolific local school but one that included artists like Lubin Baugin and Jean-Baptiste Oudry and was dominated by the genius of Jean-Baptiste-Siméon Chardin, one of the greatest interpreters of the evolution of the still life in the 18th century.

In his *Cours de peinture par principes*, published in 1708, Roger de Piles wrote that "the true painting is that which calls us (so to speak) by surprising us; and it is only through the power of this effect that we are forced to approach it, as if it had something to tell us". This effect of visual and intellectual surprise and of immediacy was the characteristic that made the still life a widely practised genre after the 17th century as well, ensuring its survival down to our own day. Even after the fashion for this kind of painting had faded among collectors, the still life continued to be practised as a specific academic genre. Its character as an artificial arrangement of a series of objects whose volume, colour and relationship with light (from the opaque reverberation of velvet and linen to the transparency of glass, from the shape of crockery to the colouring of fruit) make them complicated to paint; the possibility of estab-

20

lishing a particular lighting condition in advance; the high and very close point of view of the subject; its nature as a description of objects that are insignificant in themselves, and thus neutral with respect to the aim of making the most of their beauty pictorially: all these characteristics made the still life the ideal subject for a painting that relied only on itself and its own expressive intensity, on a perfectly balanced mix of technical acumen and sharp visual intelligence. Through it modern art, free from constraints of a religious, moral or educational nature, was able to fully express its own independent ability to produce meaning.

So, if on one hand the Romantic revolt demanded total freedom for the artist in the choice and treatment of subjects, in the name of individual genius, a different current of painting in the 19th century continued to plumb this genre precisely because, with the cancelling out of any specific value of the subject, it was the individual style, the specific artistic manner, that dominated the work.

On following pages
Pierre Roy
A Day in the Country
(*Still Life*) (detail), 1932
Oil on canvas, 33 x 55 cm
Musée national d'Art
moderne – Centre Georges
Pompidou, Paris

Memorable still lifes were painted by Eugène Delacroix and Gustave Courbet, but it was Manet and the Impressionists who ushered in a new and important period for the genre. The artists for whom the immediate optical impression, the pulsation of life, the elementary visual event and the ceaseless changing of the light were the new stylistic and conceptual gospel saw in the arrangement of simple objects on a support not just the possibility of underlining the difference in their approach to that of the traditional art from which they were trying to break free, but also that of experimenting with a totally new way of composing and depicting, relying solely on the sensitivity of the eye and the hand.

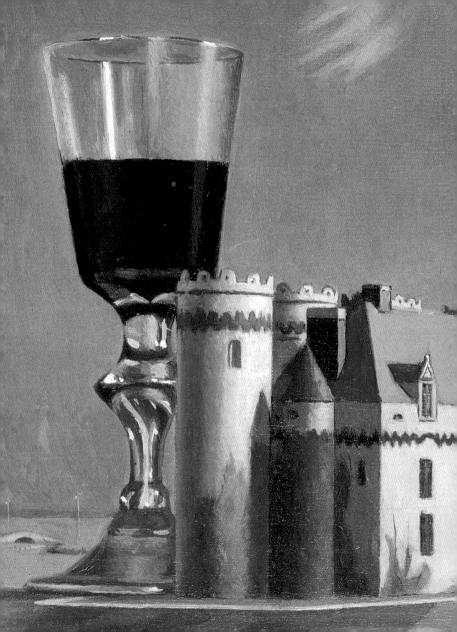

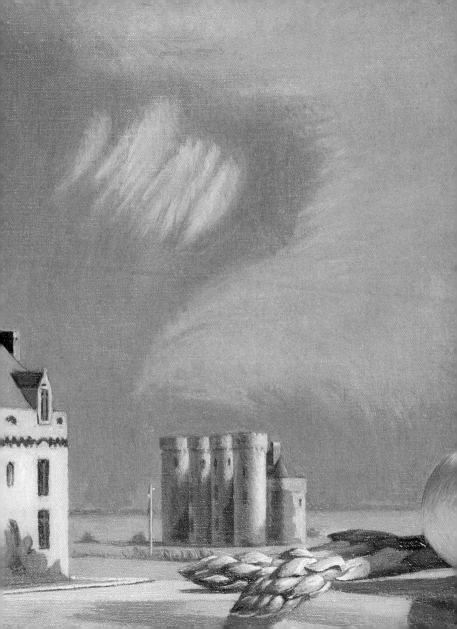

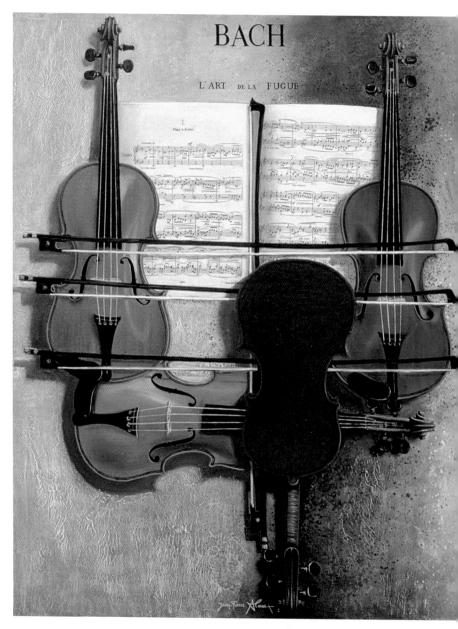

The Impressionist still life marked the foundation of a new tradition of the genre: the course taken by the avant-gardes that emerged from the movement meant that it became one of the most fiercely fought cultural battlegrounds in the subsequent series of controversies and revolutions. Van Gogh, Gauguin and Matisse inaugurated one current, later explored by artists like Soutine, de Pisis and Fautrier, in which what counted most was the attempt to convey the aspects of quivering and lavish, yet subtly mortal vitality to be found in things.

Cézanne, however, declared: "Everything we see falls apart, vanishes. Nature is always the same, but nothing in her that appears to us, lasts. Our art must render the thrill of her permanence along with her elements, the appearance of all her changes. It must give us the taste of her eternity".

**Jean-Pierre Alaux
(1925-)**
The Art of Fugue
Private collection

Distinguishing himself with great determination from the Impressionist cult of pure sensations, he even revived the ancient theme of *vanitas* in the still life in an attempt to capture in his works the fleeting sense of existence, along with the solidity of form underlying appearances, something which allowed his painting to go beyond mere sensation and attain a distilled classical measure by analyzing what he saw rather than applying preconceived intellectual rules to it.

It was Cézanne's insight that prompted Pablo Picasso, Georges Braque and Juan Gris, at the height of the Cubist period, to turn to the still life as a perfect exercise in the reconstruction of a plastic reality that transcended the perceptible nature of the objects: from fruit to crockery, from musical instruments to fabrics, the variety of the objects' forms became a laboratory for the geometrical reworking of the visible world.

25

Another approach to the still life genre developed in parallel to that of the Cubists, one which utilized it as a means of constructing enigmatic images. The young de Chirico employed the rhetorical element of the presentation of objects (fish, biscuits, bananas and toys, for example) to accentuate the effect of lucid spatial and temporal alienation in Metaphysical painting: later on, at the time when his attention turned back to the classical tradition, he would object to the Italian term *natura morta* or "dead nature", preferring to use the more pertinent title of *Vita silente* or *Silent Life* for his compositions.

Another member of the Metaphysical movement was the young Giorgio Morandi, unquestionably the greatest exponent of the modern still life, for whom de Chirico himself, in 1922, coined the expression "metaphysics of everyday things", going on to say: "These objects are dead for us because they are immobile. But [Morandi] looks at them with belief. He finds comfort in their inner structure – their eternal aspect".

De Chirico and Morandi became the points of reference for entire generations that set out to find a mode of representation which would surpass Cubism in terms of an essential and analytical vision, described by Ardengo Soffici as the "modernity that harks back to the majesty of the past": figures like Le Corbusier, Léger, Casorati, Donghi and Kanoldt all set themselves this goal.

Moreover, experiences like those of Morandi, Donghi and the artists of the German Neue Sachlichkeit or New Objectivity movement finally brought to a head the confrontation that had been going on for decades between photography and painting in the field of the still life as well. Ever since its beginnings around the middle of the

19th century, in fact, the emerging art of photography had formulated its own technical methods and imagery, making the triad of painting genres *par excellence*, the portrait, the landscape and the still life, its favourite field of experimentation. Among them, the still life represented the one in which the photographer was no longer conditioned by the subject, by the circumstance, but could construct and select the image in view of a specific expressive objective.

Building on the work of the pioneers Henry Fox Talbot, August Kotzsch and Henri Le Secq and on such fundamental experiences in the 20th century as those of Florence Henri, Edward Weston, André Kertész and Man Ray, the still life has found itself a permanent place in contemporary photography, achieving brilliant results in more recent times in the hands of artists like Robert Mapplethorpe and Joan Fontcuberta.

The period since the Second World War has seen the story of the still life reach a climax that is at once definitive and tautological. If, at its birth, the still life was a pictorial redemption of trivial things, from Dadaism to Pop Art the neo-avant-gardes of the 20th century have opted for the direct, crude and assertive display of the things themselves.

The Duchampian ready-made is at the root of the accumulations of objects in the form of an estranged still life that characterizes the work of artists like Daniel Spoerri, Arman, Tom Wesselmann and Andy Warhol, and after them Joseph Beuys and the exponents of Arte Povera, in a reclamation for art of things as such.

On following pages
Georges Rohner
Music (detail), *circa* 1930
Tapestry
Mobilier national, Paris

Works

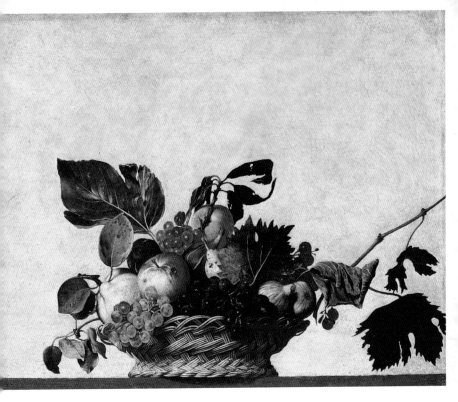

1. Caravaggio
Basket of Fruit, 1594-98

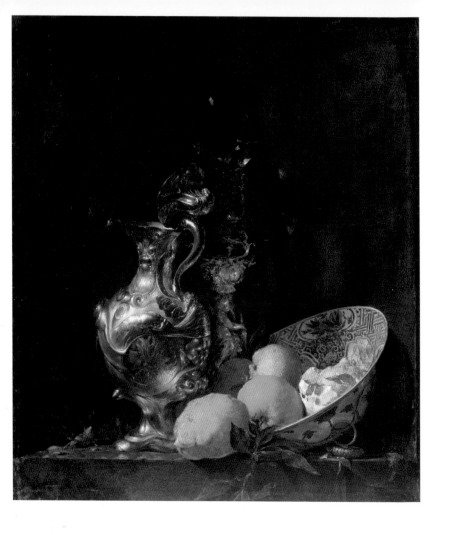

2. Willem Kalf
Still Life with Silver Jug,
circa 1660

3. Jan van de Velde
Still Life with Beer Glass,
1647

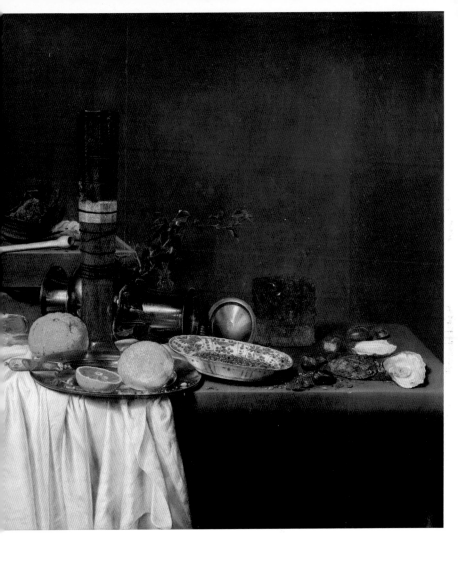

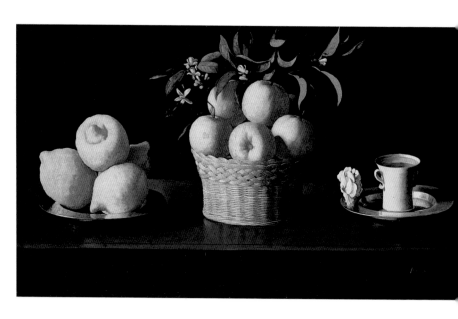

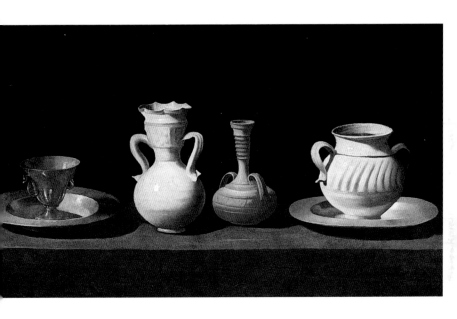

4. Francisco de Zurbarán
Still Life with Lemons,
Oranges and a Rose, 1633

5. Francisco de Zurbarán
Still Life, circa 1660

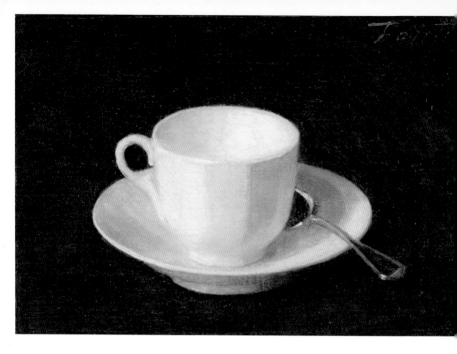

36

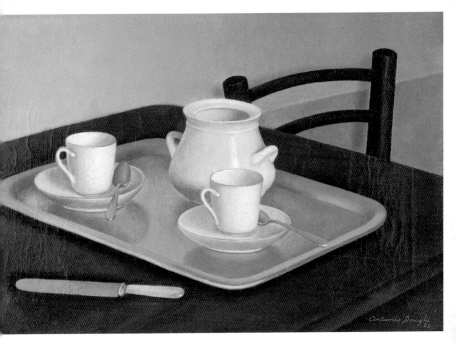

6. Henri de Fantin-Latour
Cup and Saucer, 1864

7. Antonio Donghi
Still Life, 1928

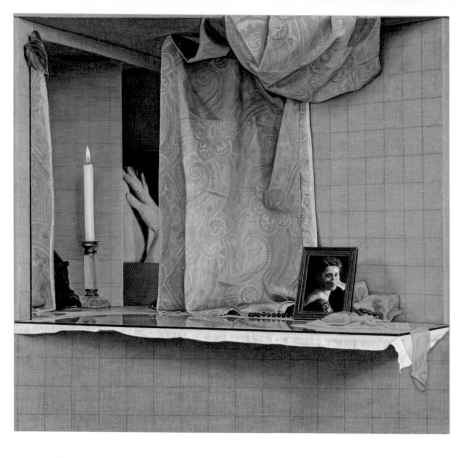

**8. Christopher
Kilmartin**
Hairdresser, 1978

**9. Samuel
van Hoogstraten**
The Slippers, 1658

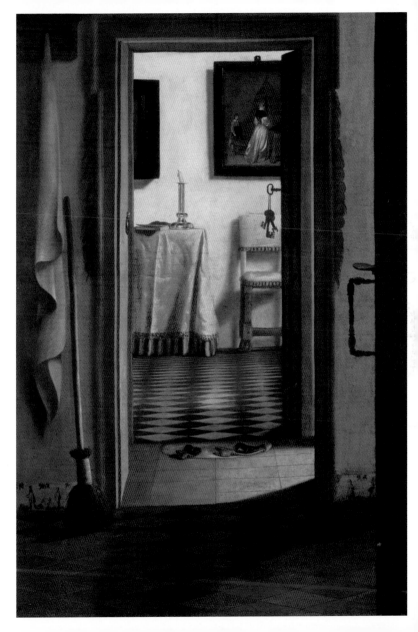

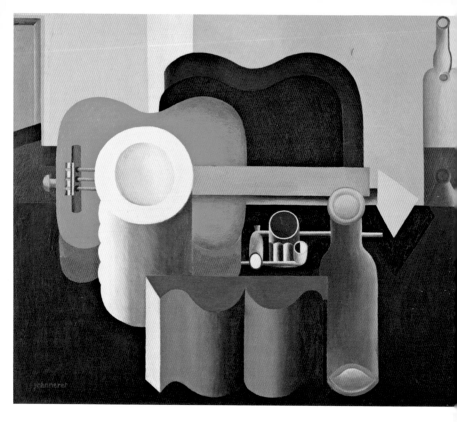

10. Le Corbusier
*Still Life with Stack
of Plates and Book*, 1920

11. Georges Braque
Guéridon, 1929

40

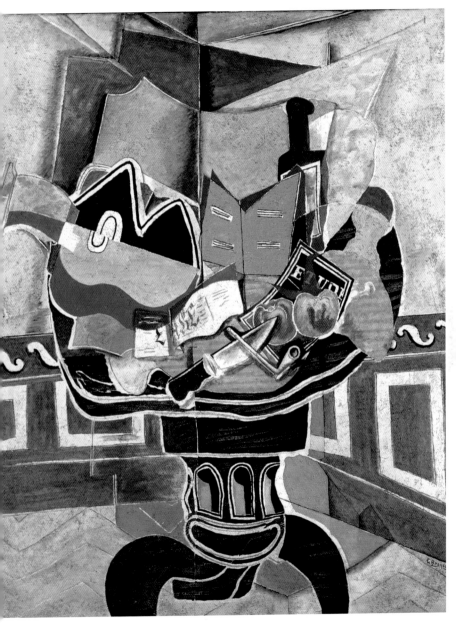

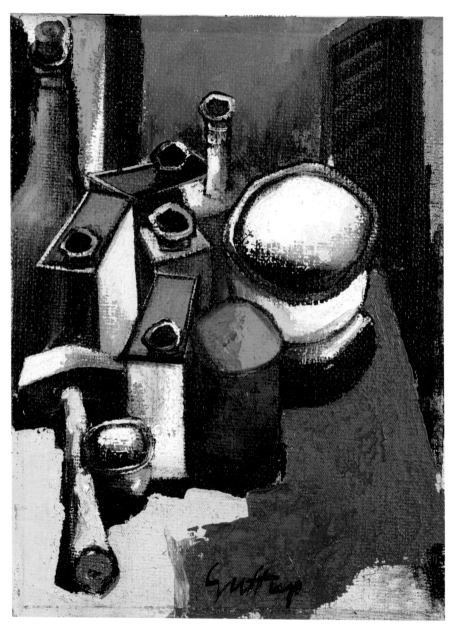

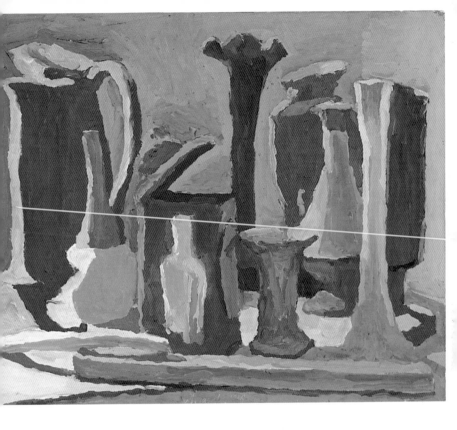

12. Renato Guttuso
Composition, 1967

13. Giorgio Morandi
Still Life, 1936

43

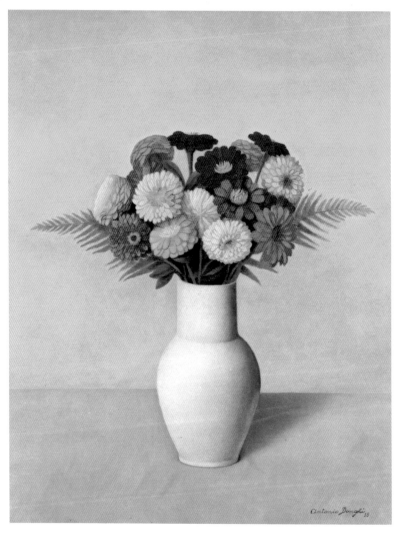

Antonio Donghi 35

14. Antonio Donghi
Flowers, 1935

15. Henri Rousseau
Bouquet of Flowers,
1895-1900

44

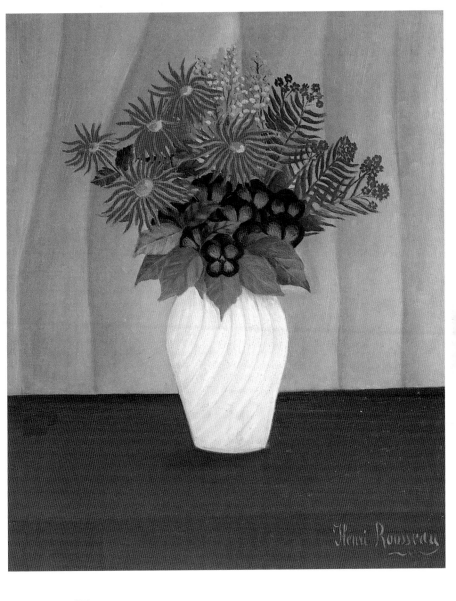

45

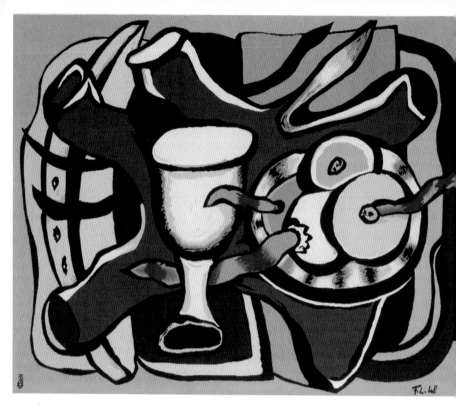

16. Fernand Léger
Still Life with Apples, 1948

17. Bros
*The Last Supper
(Revisiting the Death of
the Father of Many)*, 2007

46

3

47

18. Pierre Roy
A Day in the Country
(*Still Life*), 1932

19. René Magritte
Personal Values, 1952

48

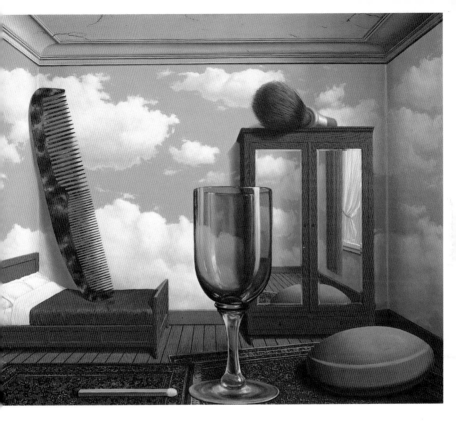

49

50

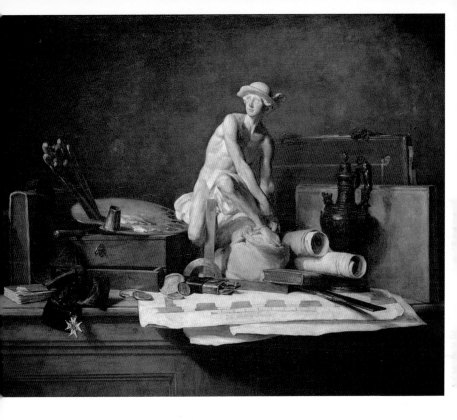

20. Pieter Claeszoon
Still Life with the Spinario,
1628

**21. Jean-Baptiste-
Siméon Chardin**
*Still Life with the Attributes
of the Arts*, 1766

On following pages
22. Vincent van Gogh
Vincent's Chair, 1888

23. Vincent van Gogh
Gauguin's Chair, 1888

51

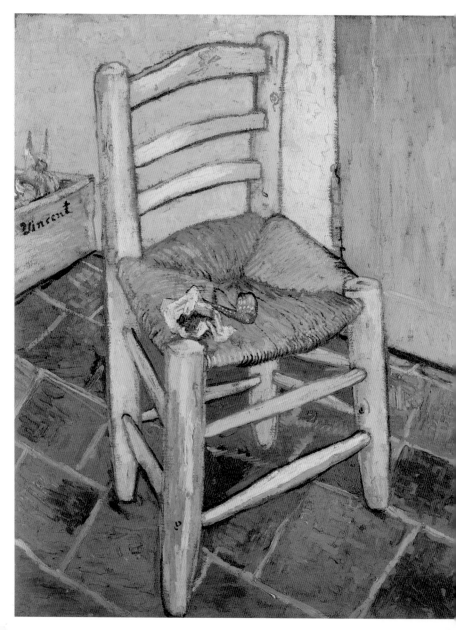

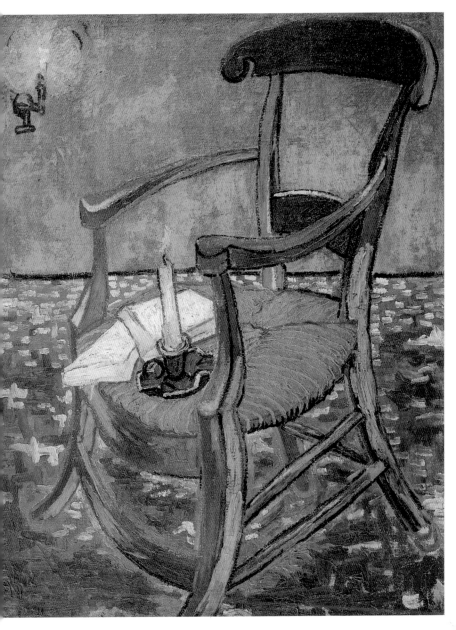

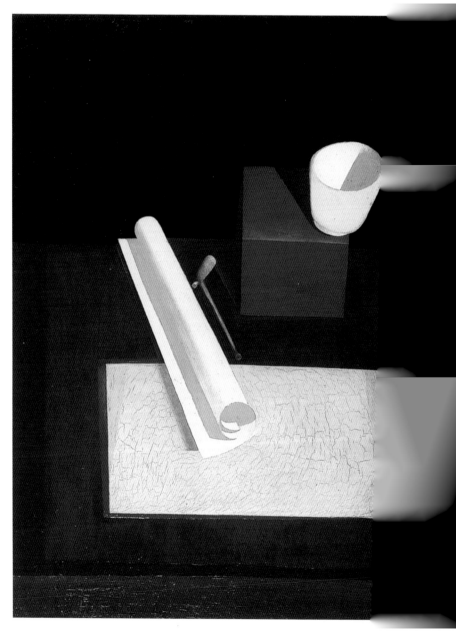

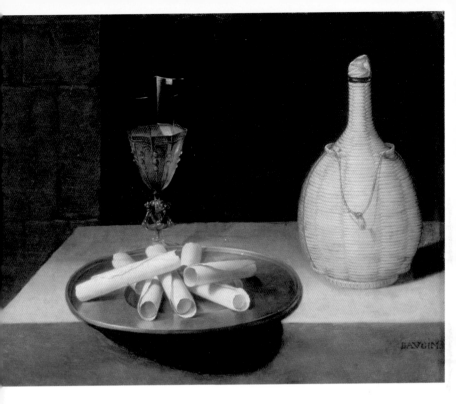

24. Le Corbusier
Le bol rouge
(*The Red Bowl*), 1919

25. Lubin Baugin
*Still Life with Wafer
Biscuits*, 1630-35

55

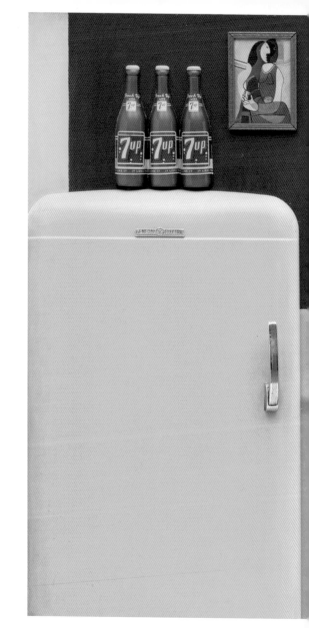

26. Tom Wesselmann
Still Life #30, 1963

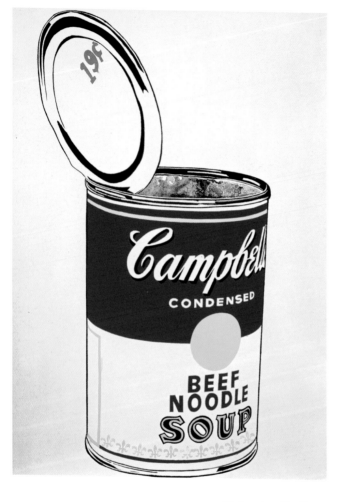

27. Andy Warhol
*Big Campbell's Soup Can,
19 Cents*, 1962

28. Jean-Luc Moulène
*24 objets de grève
présentés par Jean-Luc
Moulène* (*24 Strike
Objects Presented by
Jean-Luc Moulène*), 1999

GAULOISES

PANTINOISES

DÉGUSTATION

VENTE INTERDITE

CGT

JACNO

20 CIGARETTES
Fabriquées par
les travailleurs en lutte

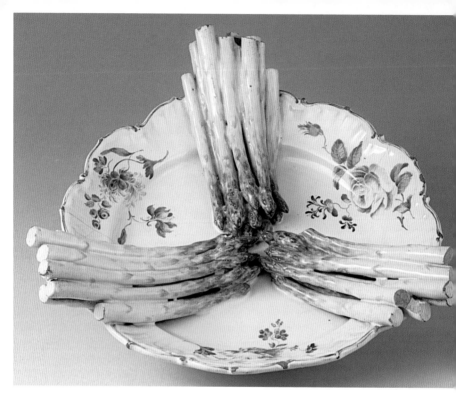

29. Sceaux Factory
Dish with Asparagus,
18th century

30. Édouard Manet
Asparagus, 1880

On following pages
31. *Unswept Floor,*
1st century AD

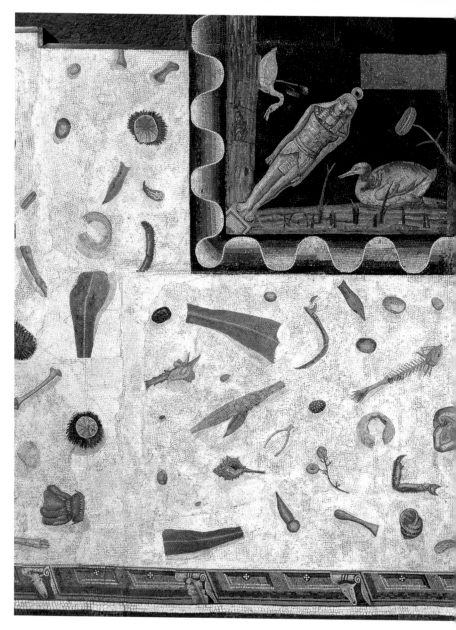

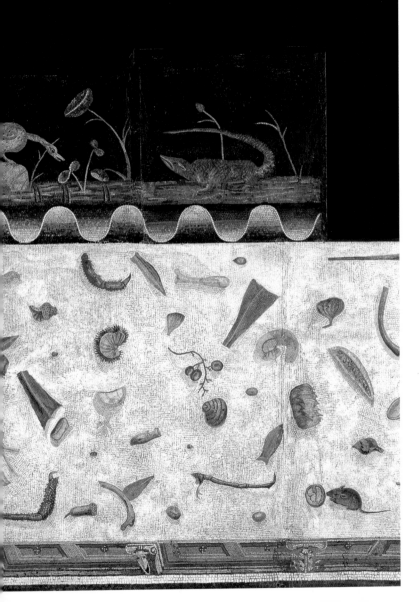

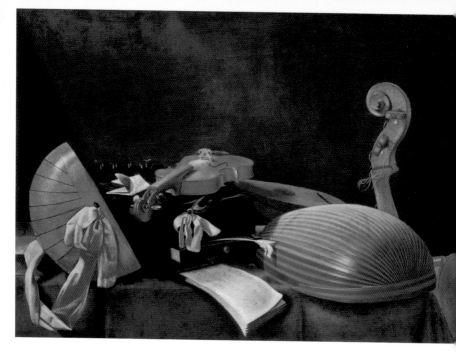

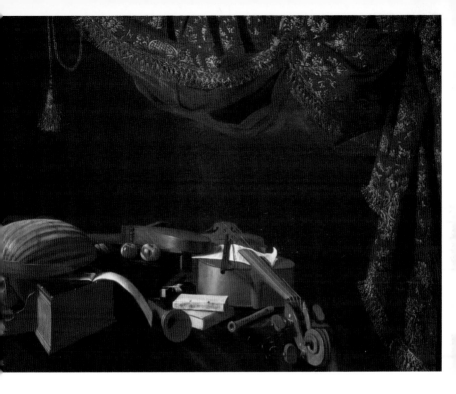

32. Evaristo Baschenis
Still Life with Musical Instruments, circa 1650

33. Evaristo Baschenis
Still Life with Musical Instruments and Curtain, circa 1650

On following pages
34. Raphael
The Ecstasy of Saint Cecilia between Saints Paul, John the Evangelist, Augustine and Mary Magdalene (detail), 1513

65

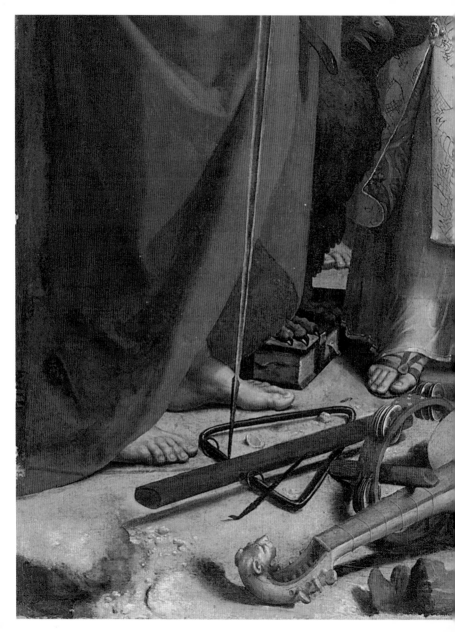

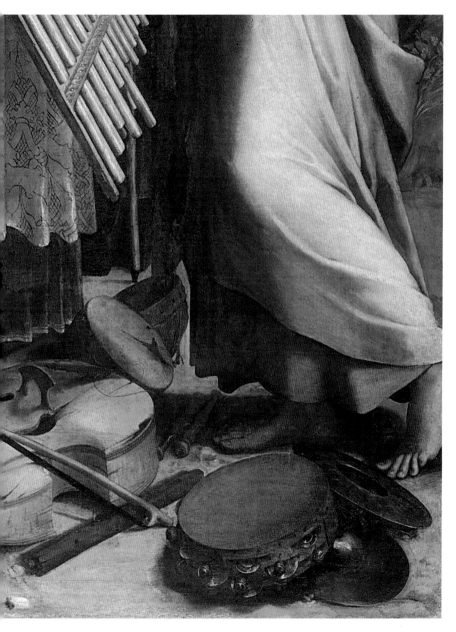

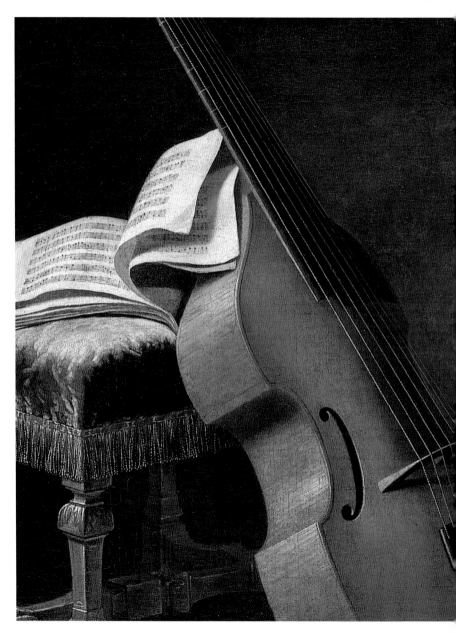

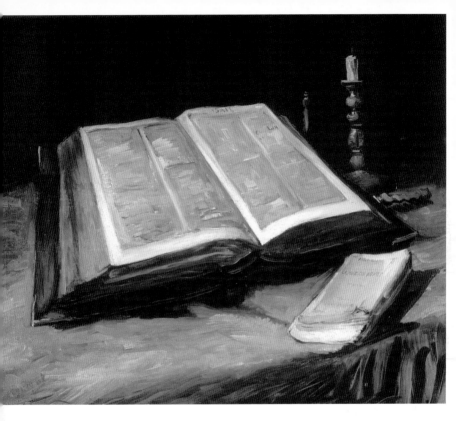

35. Michel Boyer
*Bass Viol, Score Sheet and
a Sword* (detail), 1693

36. Vincent van Gogh
*Still Life with Open Bible,
Candlestick and Novel*, 1885

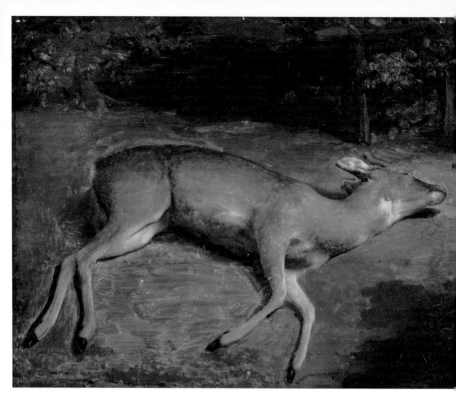

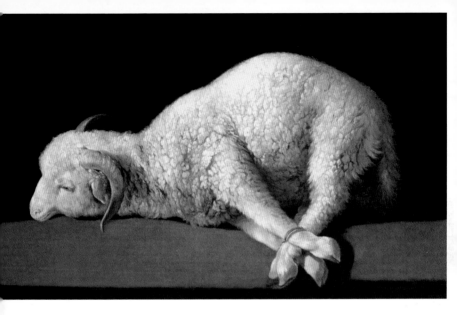

37. Gustave Courbet
Dead Deer, 1857

**38. Francisco
de Zurbarán**
Agnus Dei, circa 1635-40

71

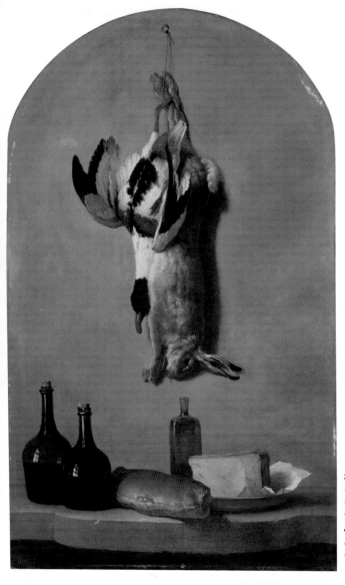

39. Jean-Baptiste Oudry
*Still Life: Hare, Duck,
Loaf of Bread, Cheese
and Flasks of Wine*, 1742

40. Jean-Baptiste Oudry
*Antler of a Deer against
a Background of Boards*,
1741

72

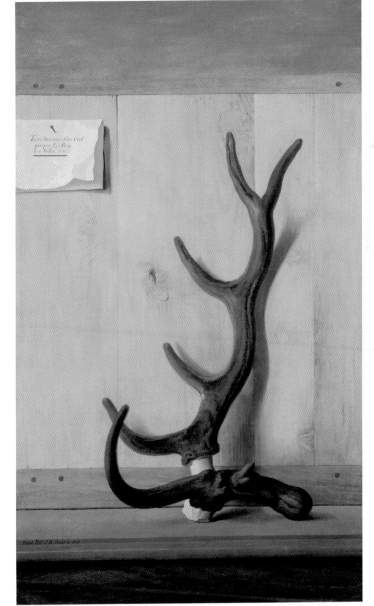

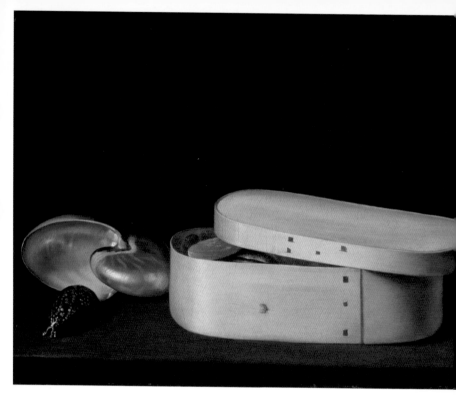

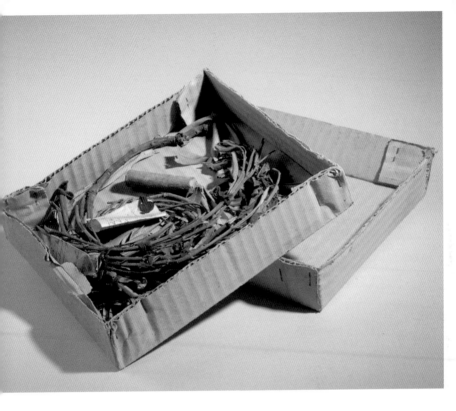

41. Sebastian Stoskopff
*Still Life with a Nautilus,
Panther Shell and Chip-
Wood Box, circa* 1630

42. *Box with the remains
of a wreath of willow
fronds placed on
Napoleon's tomb on Saint
Helena*, recovered in 1840

75

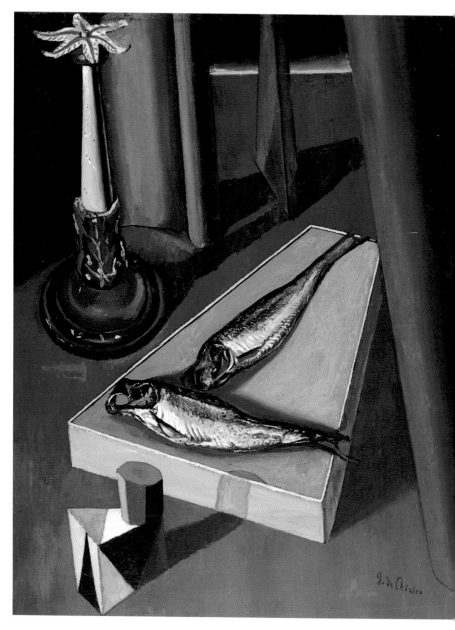

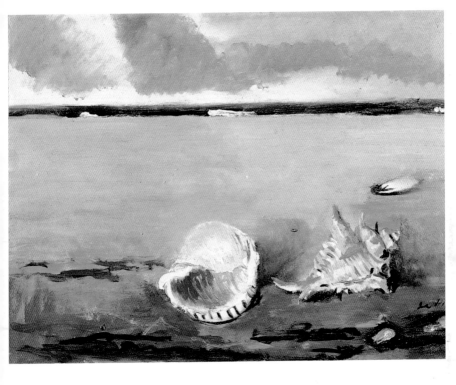

43. Giorgio de Chirico
The Sacred Fish, 1919

44. Filippo De Pisis
Marine Still Life, 1929

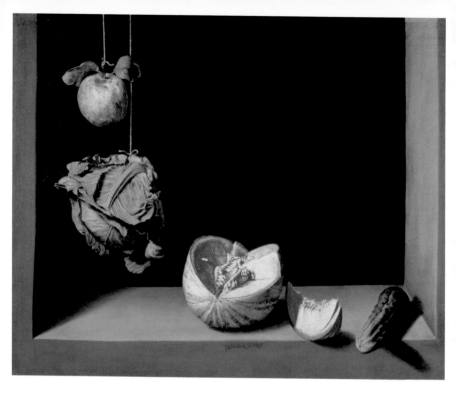

78

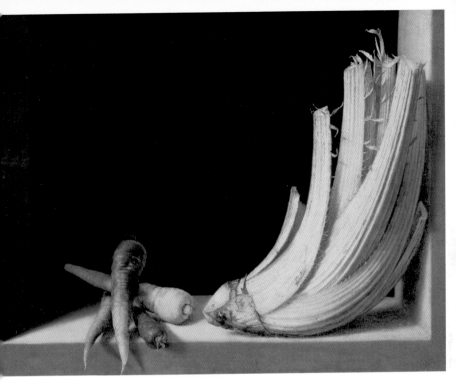

45. Juan Sánchez Cotán
*Still Life with Cabbage,
Melon and Cucumber*,
before 1603

**46. Juan Sánchez
Cotán**
Still Life with a Cardoon,
circa 1602

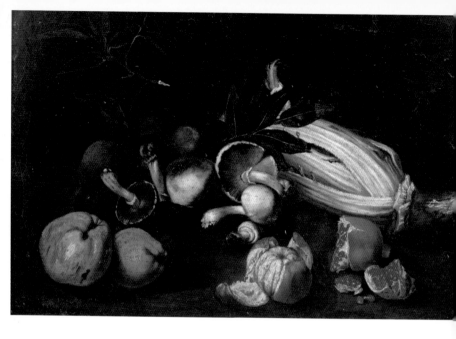

**47. Giovan Battista
Ruoppolo (1620-85)**
Still Life

**48. Luis Eugenio
Meléndez**
*Still Life with Bread
and Figs*, circa 1770

80

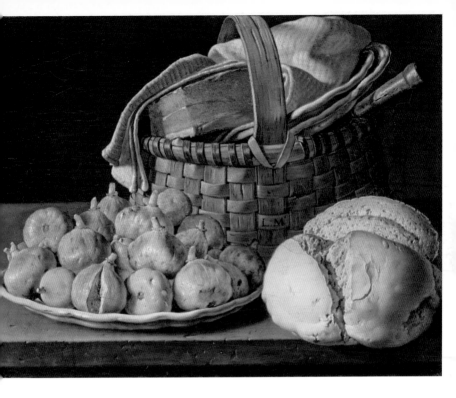

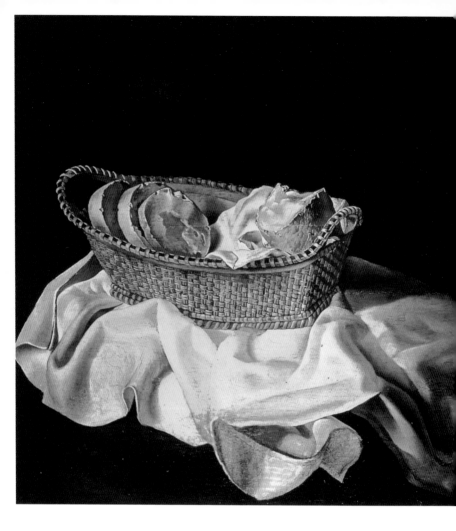

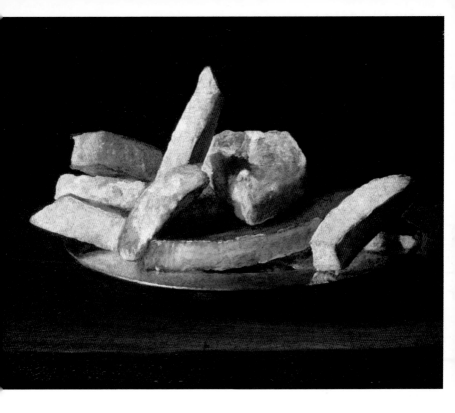

49. Salvador Dalí
Basket of Bread, 1926

50. Francisco de
Zurbarán (1598-1664)
Still Life

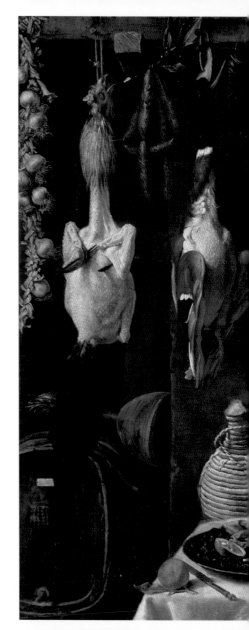

51. Jacopo da Empoli
*Still Life with Goose,
Poultry and Game*, 1624

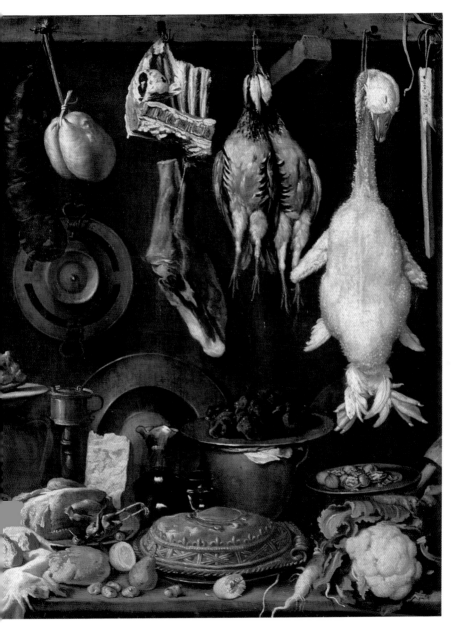

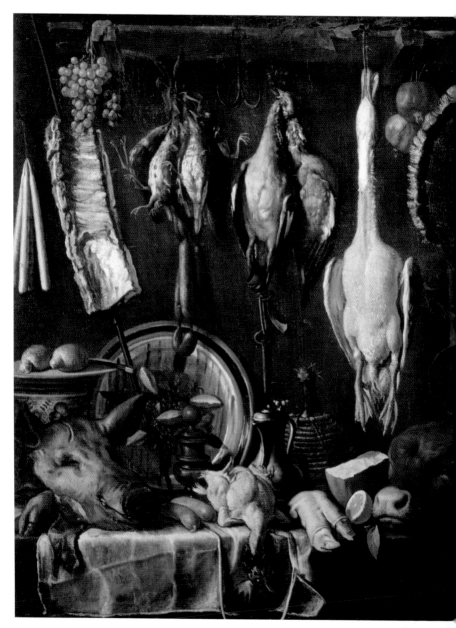

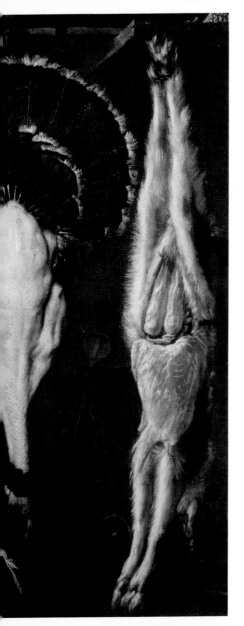

52. Jacopo da Empoli
*Still Life with Turkey,
Hare and Game*, 1621

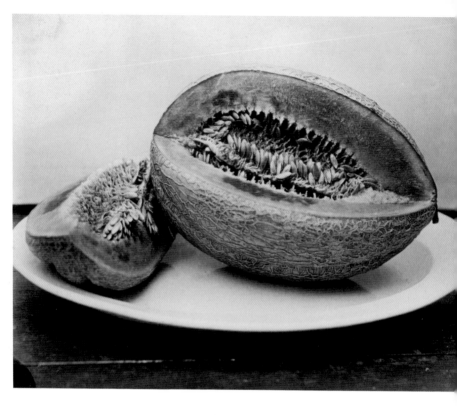

53. August Kotzsch
Melon, circa 1870

54. Robert Mapplethorpe
Watermelon and Knife, 1985

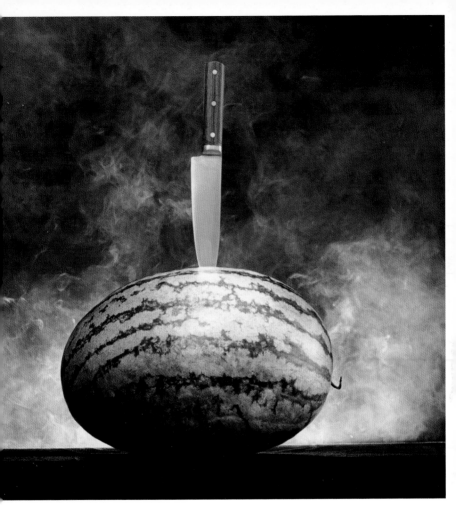

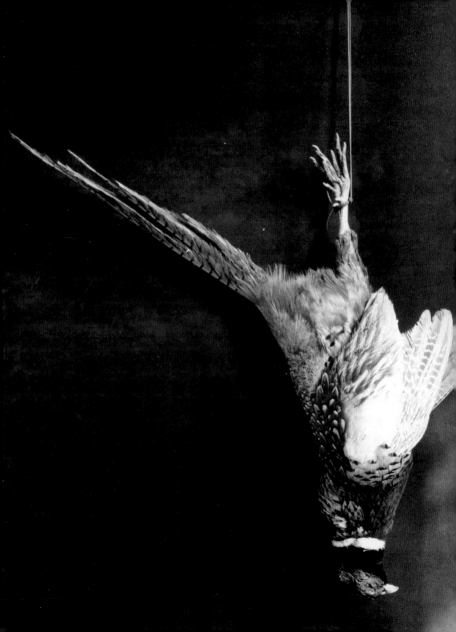

Appendix

Catalogue
of the Works

1. Caravaggio
Basket of Fruit, 1594-98
Oil on canvas, 31 x 47 cm
Pinacoteca Ambrosiana, Milan

2. Willem Kalf
Still Life with Silver Jug,
circa 1660
Oil on canvas,
73.8 x 65.2 cm
Rijksmuseum, Amsterdam

3. Jan van de Velde
Still Life with Beer Glass,
1647
Oil on wood, 64 x 59 cm
Rijksmuseum, Amsterdam

4. Francisco de Zurbarán
*Still Life with Lemons,
Oranges and a Rose*, 1633
Oil on canvas, 62 x 109.5 cm
Norton Simon Museum
of Art, Pasadena

5. Francisco de Zurbarán
Still Life, circa 1660
Oil on canvas, 46 x 84 cm
Museo Nacional del Prado,
Madrid

6. Henri de Fantin-Latour
Cup and Saucer, 1864
Oil on canvas, 18 x 27.4 cm
Fitzwilliam Museum,
Cambridge

7. Antonio Donghi
Still Life, 1928
Oil on canvas, 34 x 51 cm
Giuseppe Bertolami
Collection, Rome

8. Christopher Kilmartin
Hairdresser, 1978
Oil on canvas, 76 x 81 cm
Musée national d'Art
moderne – Centre Georges
Pompidou, Paris

**9. Samuel van
Hoogstraten**
The Slippers, 1658
Oil on canvas, 103 x 70 cm
Musée du Louvre, Paris

10. Le Corbusier
*Still Life with Stack of Plates
and Book*, 1920
Oil on canvas, 80.9 x 99.7 cm
The Museum of Modern Art,
New York

11. Georges Braque
Guéridon, 1929
Oil, sand and charcoal on
canvas, 145.6 x 113.8 cm
Phillips Collection, Paris

12. Renato Guttuso
Composition, 1967
Oil on canvas, 40 x 30 cm
Private collection, Rome

13. Giorgio Morandi
Still Life, 1936
Oil on canvas, 51 x 62.5 cm
MART – Museo d'Arte
Contemporanea di Trento
e Rovereto, Rovereto
Giovanardi Collection

14. Antonio Donghi
Flowers, 1935
Oil on canvas, 50 x 40 cm
Banca di Roma Collection,
Rome

15. Henri Rousseau
Bouquet of Flowers,
1895-1900
Oil on canvas, 61 x 49 cm
Tate Modern, London

16. Fernand Léger
Still Life with Apples, 1948
Oil on canvas, 152 x 195 cm
Musée national Fernand
Léger, Biot

17. Bros
*The Last Supper
(Revisiting the Death
of the Father of Many)*, 2007
Gloss enamel on canvas,
300 x 300 cm
Private collection

18. Pierre Roy
*A Day in the Country
(Still Life)*, 1932
Oil on canvas, 33 x 55 cm
Musée national d'Art
moderne – Centre Georges
Pompidou, Paris

19. René Magritte
Personal Values, 1952
Oil on canvas, 80 x 100 cm
Museum of Modern Art, San
Francisco

20. Pieter Claeszoon
Still Life with the Spinario,
1628
Oil on wood, 70.5 x 80.5 cm
Rijksmuseum, Amsterdam

**21. Jean-Baptiste-Siméon
Chardin**
*Still Life with the Attributes
of the Arts*, 1766
Oil on canvas,
112 x 140.5 cm
State Hermitage Museum,
St Petersburg

22. Vincent van Gogh
Vincent's Chair, 1888
Oil on canvas, 93 x 73.5 cm
The National Gallery, London

23. Vincent van Gogh
Gauguin's Chair, 1888
Oil on canvas, 90.5 x 72.5 cm
Rijksmuseum Vincent
van Gogh, Amsterdam

24. Le Corbusier
Le bol rouge
(*The Red Bowl*), 1919
Oil on canvas, 81 x 65 cm
Fondation Le Corbusier, Paris

25. Lubin Baugin
Still Life with Wafer Biscuits,
1630-35
Oil on wood, 41 x 52 cm
Musée du Louvre, Paris

26. Tom Wesselmann
Still Life #30, 1963
Oil, enamel and synthetic
polymer paint on composition
board with collage of printed
advertisements, plastic
flowers, refrigerator door,
plastic replicas of 7-Up
bottles, glazed and framed
colour reproduction
and stamped metal,
122 x 167.5 x 10 cm
The Museum of Modern Art,
New York

27. Andy Warhol
*Big Campbell's Soup Can,
19 Cents*, 1962
Casein and pastel on canvas,
182.9 x 137.2 cm
Menil Collection, Houston

28. Jean-Luc Moulène
*24 objets de grève présentés
par Jean-Luc Moulène*
(*24 Strike Objects Presented
by Jean-Luc Moulène*), 1999
Perspex
Musée national d'Art moderne
– Centre Georges Pompidou,
Paris

29. Sceaux Factory
Dish with Asparagus,
18th century
Faïence, 35 cm (diameter)
Musée national de
Céramique, Sèvres

30. Édouard Manet
Asparagus, 1880
Oil on canvas, cm 16 x 21
Musée d'Orsay, Paris

31. *Unswept Floor*,
1st century AD
Mosaic, from Vigna Lupi
Vatican Museums, Vatican
City

32. Evaristo Baschenis
*Still Life with Musical
Instruments*, circa 1650
Oil on canvas, 75 x 108 cm
Accademia Carrara, Bergamo

33. Evaristo Baschenis
*Still Life with Musical
Instruments and Curtain*,
circa 1650
Oil on canvas, 95 x 128 cm
Accademia Carrara, Bergamo

34. Raphael
*The Ecstasy of Saint Cecilia
between Saints Paul, John
the Evangelist, Augustine
and Mary Magdalene* (detail),
1513
Oil on wood transferred
onto canvas, 238 x 150 cm
Pinacoteca Nazionale,
Bologna

35. Michel Boyer
*Bass Viol, Score Sheet
and a Sword* (detail), 1693
Oil on canvas, 99 x 81 cm
Musée du Louvre, Paris

36. Vincent van Gogh
*Still Life with Open Bible,
Candlestick and Novel*, 1885
Oil on canvas, 65 x 78 cm
Rijksmuseum Vincent
van Gogh, Amsterdam

37. Gustave Courbet
Dead Deer, 1857
Oil on canvas, 33 x 41 cm
Musée d'Orsay, Paris

38. Francisco de Zurbarán
Agnus Dei, circa 1635-40
Oil on canvas, 38 x 62 cm
Museo Nacional del Prado, Madrid

39. Jean-Baptiste Oudry
Still Life: Hare, Duck, Loaf of Bread, Cheese and Flasks of Wine, 1742
Oil on canvas, 143 x 87 cm
Musée du Louvre, Paris

40. Jean-Baptiste Oudry
Antler of a Deer against a Background of Boards, 1741
Oil on canvas, cm 115 x 69
Château de Fontainebleau, Fontainebleau

41. Sebastian Stoskopff
Still Life with a Nautilus, Panther Shell and Chip-Wood Box, circa 1630
Oil on canvas, 47 x 59.4 cm
The Metropolitan Museum of Art, New York

42. *Box with the remains of a wreath of willow fronds placed on Napoleon's tomb on Saint Helena*, recovered in 1840
Château de Malmaison et Bois-Préau, Malmaison

43. Giorgio de Chirico
The Sacred Fish, 1919
Oil on canvas, 75 x 72 cm
The Museum of Modern Art, New York
Lillie P. Bliss Bequest

44. Filippo De Pisis
Marine Still Life, 1929
Oil on paper with canvas backing, 50 x 71 cm
MART – Museo d'Arte Contemporanea di Trento e Rovereto, Rovereto
Giovanardi Collection

45. Juan Sánchez Cotán
Still Life with Cabbage, Melon and Cucumber, before 1603
Oil on canvas, 68.9 x 84.5 cm
Museum of Art, San Diego

46. Juan Sánchez Cotán
Still Life with a Cardoon, circa 1602
Oil on canvas, 62 x 82 cm
Museo de Bellas Artes, Granada

47. Giovan Battista Ruoppolo (1620-85)
Still Life
Oil on canvas
Museo Mandralisca, Cefalù

48. Luis Eugenio Meléndez
Still Life with Bread and Figs, circa 1770
Oil on canvas, 37 x 49 cm
Musée du Louvre, Paris

49. Salvador Dalí
Basket of Bread, 1926
Oil on wood, 31.5 x 31.5 cm
Salvador Dalí Museum, Saint Petersburg (Florida)

50. Francisco de Zurbarán (1598-1664)
Still Life
Oil on canvas
Private collection, Madrid

51. Jacopo da Empoli
Still Life with Goose, Poultry and Game, 1624
Oil on canvas, 119 x 152 cm
Galleria degli Uffizi, Florence

52. Jacopo da Empoli
Still Life with Turkey, Hare and Game, 1621
Oil on canvas, 129 x 151 cm
Galleria degli Uffizi, Florence

53. August Kotzsch
Melon, circa 1870
Albumin print, 14.9 x 19.2 cm
Kupferstichkabinett, Dresden

54. Robert Mapplethorpe
Watermelon and Knife, 1985
Silver gelatine print, 50.5 x 40 cm
Robert Mapplethorpe Foundation, New York

Selected Bibliography

I. Bergström, *Dutch Still Life Painting in the Seventeenth Century*, London 1956

C. Sterling, *La nature morte de l'antiquité à nos jours*, Paris 1959

J.T. Spike, *Italian Still Life Paintings from Three Centuries*, exibition catalogue, Florence 1983

N. Schneider, *Still Life Paintings in the Early Modern Period*, Köln 1994

P. Taylor, *Dutch Flower Painting: 1600-1720*, New Haven-London 1995

W.B. Jordan (edited by), *Spanish Still Life Painting from Sánchez Cotán to Goya*, London 1997

M. Rowell (edited by), *Objects of Desire: the Modern Still Life*, New York 1997

G. Mauner, *Manet: the Still Life Paintings*, exibition catalogue, New York 2000

A. van der Willigen, F.G. Meijer, *A dictionary of Dutch and Flemish Still Life painters working in oils: 1525-1725*, Leiden 2003

J. Sander (edited by), *The Magic of Things: Still Life Painting 1500-1800*, Frankfurt 2008

DO 9847722048

STILL LIFE

INGLESE
GUALDONI

MINI-SMART
SKIRA